T0129279

The Love and Mercy of God

Gail Mainor

authorHOUSE®

AuthorHouse™
1663 Liberty Drive
Bloomington, IN 47403
www.authorhouse.com
Phone: 1-800-839-8640

Published by AuthorHouse 2/13/2013

ISBN: 978-1-4817-0667-4 (sc)
ISBN: 978-1-4817-0668-1 (e)

Library of Congress Control Number: 2013900545

Any people depicted in stock imagery provided by Thinkstock are models,
and such images are being used for illustrative purposes only.
Certain stock imagery © Thinkstock.

This book is printed on acid-free paper.

Because of the dynamic nature of the Internet, any web addresses or
links contained in this book may have changed since publication and
may no longer be valid. The views expressed in this work are solely those
of the author and do not necessarily reflect the views of the publisher,
and the publisher hereby disclaims any responsibility for them.

The contents that is in this book is to allow those that read it to really search their lives and realize that they need the savior to come in their hearts and save them from themselves. Find unconditional love that will not stop reaching out for them no matter where they are in life.

I dedicate this book to my sister Roselie, who has gone home to be with the Lord Jesus Christ.

She played a big part in my life before and after we were saved.

She suffered for many so that they could get to know Jesus. She showed my children and me lots of love, and she sacrificed herself and her time on many occasions for us.

So I say thank you, sister, and we will see you when we get to heaven. You said you were going to see Jesus before me, and you did.

I first want to begin by saying
I once was lost, but now I'm found.
I was blind, but now I can see.

Chapter 1

I ONCE DID NOT know why I was here on earth, what my purpose in life was. Then the Lord God Almighty introduced me to his love through his son, Christ Jesus. For the first time in my life, I experienced real love undefiled, pure, and holy—the love of God that passes all knowledge and all understanding.

Many people look for love all of their lives. They look for it in their parents. They look for it in their sisters or brothers (biological and spiritual). They look for it in friends. Do not misunderstand what I am saying. Yes, they love you, but human love is limited. Some of us fall in love, get married, and have children, yet we still feel empty inside, knowing something is missing. That emptiness is unexplainable. Some people have a good life—they grew up in a good and loving family environment—and have everything they need and want. Still, they feel a kind of emptiness inside that they cannot explain.

You see, love is like a medicine: it can nurture anyone into good health mentally, physically, and spiritually. We need love to survive like we need food to survive. Some of us, like myself, did not have a good, loving, comfortable, and safe childhood. I never experienced a hug or a kiss; I never heard my parents say, "I love you." I have nine sisters and two

brothers. My dad was born with a heart disease, so he could not work and provide for his family as he wanted. I guess that made him frustrated and angry all the time. Both my parents got drunk. My dad became very violent when he drank, and we were very fearful of him. We would run and hide when my parents came home drunk. He was very quiet when he didn't drink; he would sit in a chair quietly, not saying anything. I guess he was worried and was trying to figure how to take care of all his children.

He also observed us, and we paid for the least thing we did or said that he didn't like whenever he got drunk. We would have to stand in a line, side by side, and were not allowed to lean on anything or anybody for hours. If we did, we would get a beating. One of my sisters was so afraid of him that whenever she would hear my parents come in the house drunk, she would run and hide in a closet. We knew where she was because she would urinate on herself. That's how fearful we were of our dad. One time my dad had us all lined up, and my brother got so angry and tired of it that he jumped out of a window and ran away after they went to bed. I did not see him for years, but I never asked where my brother was.

In those days, children didn't ask too many questions. We were told to speak only when we were spoken to. You see, some parents didn't understand that children had something to say and had opinions. Back then, it felt like children were not humans, or like they didn't have feelings like adults did.

As I think about my childhood, I realize now that it was child abuse. Child abuse was discipline to my dad. My father didn't realize that himself, but in those times, if someone would have reported it, they would have been investigated and maybe would have been taken away from their parents. I thank God for protecting us from that. You might be thinking that's a crazy way to think, if we were being abused. It's an

experience that you would have to understand. We lived in fear, but we somehow knew that our dad loved us.

As I sit here and think about how the children are being treated in some foster homes, it's much worse than what we went through. Some of them don't survive to tell the story. Some children are raped, and some die before they can grow up and take care of themselves. I thank God for keeping us, even when we didn't know we were being kept.

The fear that I experienced caused me to become an introvert; I was very quiet. I did not talk to anyone and did a lot of thinking. All my thoughts stayed in my head. I would think so much that I did not hear when people were speaking to me. My mom would always scream at me and say I was ignoring her. Little did she know that I could not hear her, because I was in this world within myself! My family did not know that about me—I didn't allow anyone to come into my world.

I heard my older sisters talking about my brother one day when we were all together; that's how I found out he was with some guys, and one of them hit an older man and took his bottle. I still did not see him for years after that. I remember at my dad's funeral, that brother was not there. I could not understand why, but I never questioned anyone. It turned out he was in prison and was not able to go to my dad's funeral, because my mom did not have money to send for him.

I never could enjoy my siblings because of the circumstances. Everyone was always angry and mean to one another. We were treated mean, and we treated one another mean. We loved one another, but we never told one another that! You see, you can't give out something that you don't have. When you're raised without love, it's hard to give love out—and even harder to receive it. We had a hard time hugging one another. We also had a hard time accepting compliments from anyone, because all we ever said to each

other was, "I hate you. You're so ugly. I wish you would drop dead." This sounds very harsh, but this was the way we felt at that time.

My dad was very strict with all of us. We were not allowed to go outside—only to school and back. Sometimes we were allowed to sit on the steps, but no further. We did not have nice clothes like other children did; the clothes of the older ones were passed down to the younger ones. I remember wearing shoes with holes in them. We would stick newspaper in them to cover up the holes, but when it rained, the paper would get wet.

My parents would get their welfare check and then go out. When they came back drunk, they would give the older ones money to get cookies and Kool-Aid for dinner. Sometimes we had tomato sandwiches—that was a privilege. Other than that, we would have welfare food. Back then, instead of food stamps, they would have a place where we'd go with a wagon to pick up our food. If I remember correctly, the package would contain butter, lard, cornmeal, some kind of pork meat in a can, and cheese. It was called "surplus food" back then. When my mom ran out of that, we ate something that my mom called mush: it was nothing but cornmeal with sugar and butter, and it was made the same way one would fix Cream of Wheat. I did not know it was cornmeal until I was grown—all that time I thought it was hot cereal. It tasted good to me. My parents would borrow money in between checks and get lunchmeat and cheese at the store, until they got money to pay their debts. They used to tell my older sisters to go to the corner store and see if they would give them "trust." My sisters were so humiliated from that.

On major holidays like Christmas and Easter, we would get new clothing and plenty of food. My dad always made sure we had a good Christmas, and he would get a great big turkey with all the trimmings. They would also stay up all

night getting drunk and cooking Thanksgiving dinner with family members. They would sing and talk loudly all night long. At Easter time, he thought it was a good idea to buy live chicks and rabbits for us younger ones. I was scared to death of them, and I would hurry up and run past them with fear. I could not understand why he would buy them every year. They did not live long anyway. I was so happy when they would find them dead. I was too afraid to tell him I didn't like them.

I could not show any fear in front of anyone. My family would tease me all day for long periods of time and keep bringing it up whenever they wanted to get a good laugh. I thought I was the only one that was afraid, until one day one of my sisters and I were talking about old times, and I brought that up. She said she felt the same way, and we started laughing about it. I guess I was not so crazy after all.

My dad must have known something about the Lord, but he never mentioned him to us. The older ones told me that he started taking them to church just before he died; I was too young to remember that. He respected Christ's death and his resurrection to his best ability, because of his actions at Christmas and Easter. My mom used to sing spiritual hymns, but I did not know they were church songs at that time. I wish I would have known a God that answered prayers, because I would have prayed for all of us.

When my dad died, reality hit. We had never lost a loved one before. My mom told us we had better not ever say drop dead to one another again. I never had the privilege to sit on his lap or to embrace him, or to have him embrace me like a dad. My dad died at the age forty; I was about eight years old.

My childhood affected my education. I say that because I could not hear anything that the teacher was saying to me—I had a blockage. Whenever someone would talk to me,

if I were not interested in what they were saying, it did not register. I was so bitter inside that I didn't want to hear what people had to say. I hated to go home after school, because all I heard was, "You're so ugly. You're so stupid. I hate you. Get out of my face. I wish you would drop dead." When my dad died, my mom told us we had better not tell each other to drop dead. Still, we criticized each other so much that I was afraid to walk by anyone. I remember the feeling as if it was yesterday. Whenever I went to the store or outside to play, and I came back in the house, I would keep my coat on and sit in one place for hours without moving, until it was time to go to bed. I was afraid I would be criticized as I walked past them. This was a form of mental abuse.

My sisters and brothers made up nicknames for one another. I wouldn't answer them or my mom when they would ask me questions. My mom thought I was ignoring her, but as I said earlier, I was simply thinking. She would curse and call me all kinds of names. I was such an introvert that all I did was sit quiet and think all the time, lost in my own thoughts.

I was too young to take care of myself. My mom would scream if we ran the water too long in the bathtub. Most of the time she would hide the soap in her bedroom. She also had a lock on the bedroom door.

At school, I was so afraid to walk past anyone that I would not let the teacher know I had to go to the bathroom. I would sit and hold my urine until it was time to go home. I remember urinating on myself at my seat one time. Fear played a big part in my life, controlling my destiny until I meant the Lord Jesus.

We all separated after my dad died, and our lives became more difficult. The older sisters got married before my dad died and had families of their own, but the middle ones and us younger ones were left to endure this abuse.

My mother could not stand the pressure of raising us by herself. She had depended completely on my dad, and he did all the discipline. She did not have the control that he had upon us. She did not know how to survive without him, so she started neglecting us even more. She would go out and leave us for days, and we went without food.

We loved our dad. He and my mom did not go anywhere without one another. After my dad died, my mom still got drunk. It could not be with my dad anymore, so she went out by herself and came back drunk. Every time she came back drunk, she would become violent toward us. It was as if she was taking it out on us that she was left alone with all these children and didn't know how she was going to make it by herself. She would break out windows and mirrors on the wall. I stayed fearful all the time. One time she came with a stranger that we could not accept. We could never accept our mother with another man in the house; it devastated us.

The police was always at our house. My older sisters got married, moved away, and lived their own lives. Us younger ones basically raised ourselves. I realize now that God was with us all the time.

> "But God commendeth his love toward us,
> in that, while we were yet sinners, Christ
> died for us." —Romans 5:8

I would often go to the playground after school and then to my girlfriend's house, staying until it was time to go to bed. I never had anyone to sit down and ask me if I had homework and needed any help. I would be at my friend's house, and she would do her homework and get good grades. I used to hunger for that. I never told anyone that I didn't understand my schoolwork; I was too ashamed, afraid, and full of pride. I thought they would call me dumb. Every time I would go

into the classroom, and I could not hear anything. I would sometimes try to study, but as soon as the teacher would hand out the test papers, I would go into this trance and forget everything I studied.

The teacher would concentrate on the smart students, those that she thought was attentive. They were treated with kindness and respect. They got more attention and more privileges than the ones that could not comprehend or understand as quickly as the smart ones. The teachers never asked whether I was all right, or whether I was having problems learning or problems at home. She just assumed that I wasn't applying myself. I'm pretty sure she judged me by the way I dressed, and my mannerisms.

To escape going home I would go to the dances at the playground or house parties on the weekends. I would stay out until one or two in the morning, and I was so afraid that my heart would beat very fast. Sometimes I would run all the way home, but I would rather go through that than be at home all night. I hated being there. Sometimes I would run away and stay with my girlfriend for weeks, and no one from my family ever bothered to look for me. Oh, what I would have given to have a mother to greet me with open arms and say, "Where have you been? I was so worried something happened to you!" But no, I never heard those words. Instead I heard "whore" and "the B word." "You're going to be just like the rest of them, lay up and have a bunch of babies and never get married." She made me feel I would never amount to anything. That was a lie! Here I am writing a book. When my children were grown and on their own, I went back to school and got my diploma. I proved to Satan that he is a liar and the truth is not in him. All those years I waited to get my diploma, full of fear that I would fail. All I needed was just one credit. How about that? "I can do all things through Christ, who strengthens me."

My mother's names for me broke my heart. I did not know what the word "whore" meant, and neither did I know what sex meant. I was in my teenage years, and the plans I had for my life were the complete opposite of what my mom was saying. I would always imagine myself graduating and making a good life for myself. My girlfriend and I would always talk about getting a home, becoming roommates, having our own car, and being happy. Those thoughts in my situation sounded like a good thing, to finish school and get a good job. It sounded rich at that time. Graduating from college was a bit much for someone like me; where would the money come from?

But my friend and I did not think of getting married and having babies. My mom did not know the damage that she was doing to her own children. If she were still living, she would be proud of what God has done in my life. Thank God she died in Christ, saved from damnation and hell.

> "The tongue is a fire, a world of iniquity: so is the tongue among our members, that it defileth the whole body, and setteth on fire the course of nature; and it is set on fire of hell.... But the tongue can no man tame; it is an unruly evil, full of deadly poison."
> —James 3:6, 8

Chapter 2

Finding Love in the Wrong Place

I WAS TWELVE YEARS old when I met a boy people called Frog. The boys in my neighborhood would tease me and say, "Frog likes you."

I would say, "So? I like him too." But I had never seen him before.

One day I was in a restaurant where my friends would often hang out, play the pinball machine, and order hot sausages, French fries, and sodas. I finally found out who this Frog was. He had several nicknames, and my friends introduced him that night by his last name. After that day, we would always see each other at this restaurant or at the playground. He asked me if I would be his girlfriend. I said yes because I got tired of the boys throwing rocks at me and calling me stuck up. I needed someone to protect me.

My younger brother was in prison a lot, and they knew it. They were afraid of my brother because he was a good fighter, and he did not take stuff from anyone. The way we were raised caused us to be bitter and full of hatred and anger; it was Satan trying to bring to pass what my mom said I was going to be. I started believing what she was saying: that I was dumb, ugly, and unteachable.

"Whatsoever a man thinks in his heart, so is he."
—Proverbs 23:7

After I said yes to my boyfriend, the boys stopped throwing stones and harassing me. My mom and I were impressed with him. In fact, my mom loved him. He was very handsome and well dressed. He had a lot of respect, especially from elder people. He knew about love and how we were supposed to treat one another. I feared having a boyfriend because I had a fear of males. Every time I would see him coming down the street, I would run in the opposite direction. I was afraid to look at him or to speak to him, because I had so much fear of my father. I was afraid to have a boyfriend.

He was more mature and free spirited than I was. He had no idea of my situation at home; he thought my mom was nice because they got along fine. I never discussed that part of my life with him. My boyfriend, being so free spirited, made it easier for me to open up to him. I hated when he would ask me to kiss him. I had not been taught about the birds and the bees, but I wanted to remain a virgin. I just knew within myself that it was the right thing to do.

One night he invited me to go to a show with him on Christmas day. We went to his grandmother's house first because she did not live far from where we were going. He wanted to visit her because it was Christmas day, and I thought it was a good idea. He left me at her house and went to visit his cousin, who didn't live far from his grandmother's. By the time he got back, it was very late and he was drunk. I was asleep on the sofa. He went to bed, and I was on the sofa tossing and turning. All of a sudden, I heard him calling me, but I ignored him because I did not want to sleep with him. His grandmother allowed him to drink and have too much freedom.

She later came in the room to tell me he had vomit on the

floor. I was angry already because we did not go to the show like he had promised. She insisted that I go to help him clean up the mess. I went in the room so she would stop calling me. That was the end of my virginity. It was the most disgusting thing I had ever felt. I cried like a baby, and he cried also. We both experienced something that night for which we were not ready. I hated the feeling, and it did not go away right away. I felt my virginity leave, and I had no one to explain what had happened to me.

I want to say to every young girl and boy: This doesn't have to happen to you. God is able to keep you. The devil used my boyfriend's grandmother to destroy my innocence.

I felt that she wanted this to happen, because she was too persistent. She started allowing us to spend the night at her house. My boyfriend started hanging out with the wrong crowd, and he began to drink wine on the corner with other boys. I started hanging out with a girl friend of mine, and we would go to the playground dances on the weekends. I would be there more than I was at home. Her mom treated me as if I was her own daughter. I loved her mom very much; she was a wonderful mother and person. I know now that the Lord was using her for me, because she treated me with such kindness. She never asked me any of my personal business, but she treated me as if she understood. She would ask me if I wanted something to eat. Sometimes I would say no, and sometimes I could not wait for the invitation.

I remember my girlfriend called me and asked if I could come over her house, because she had a surprise for me. When I got there, she gave me a brand-new blue dress that her mom had bought for me. She bought her daughter a red dress; we would change dresses so that people would think we had new dresses. I had a special love for her mom, but I never told her because I was too uptight to show any kind of affection; I did not receive love, so I did not know how to give

out love. I pray that somehow her mom knew that I loved her. In fact, I loved her whole family because they all treated me with such kindness.

I also had a friend whose parents treated me with the same kindness, never asking any questions. The Lord knew that my personal life was very sensitive and that I chose not to share it with anyone. I stayed at her house so much her dad jokingly said that he was going to put me on his income taxes.

I finally got pregnant while I was still in school, in the twelfth grade. I quit right before I was to graduate. Isn't that something? I made it to the twelfth grade in spite of all that I was going through mentally. I guess they just passed me because I showed up.

My life was getting worse and worse. I was sad, and I didn't want to have a baby without being married. I knew the boy loved me, but I also knew that his father would be furious. He was not raised the way I was. His father was a schoolteacher, and he had good plans for his son's life—and it was not working out the way he had planned. That goes to show we can't plan our lives or anyone else's life; it never works out quite the way we plan. Some things are destined to happen. Some things we have no power over. We learn from our experiences, or at least, that's what some of us are told. The Bible tells us we learn obedience from the things that we suffer. Which one do you think is true? Some things we put on ourselves, and some things we don't have to endure.

I was sad all the time. I did not want to raise my baby without a father, and we talked about getting married. I always remembered what my mom would say to me. She would say that I would be like my sisters, having babies and never getting married. My sisters did not have different boyfriends; they each had one and ended up pregnant. You see, my dad pounded into us girls if we had more than one boyfriend, because he was afraid we'd make a name for ourselves. He

never explained sex. I was under the impression that you should only have one male friend. We should not have sex before marriage, which the Bible says is fornication, or have sex with more than one male—that was living a promiscuous life, and would be called a whore.

My dad became violent whenever he would see my sisters talk to a male. My father tried to teach us morals the best way he knew how. However, that limited us from finding what we deserved and what we sought, which was love. We never had a chance to find love. We got what presented itself as love, a false sense of security, a false love. My dad was too protective of us. He did not know how to raise us the way he should have. When you don't know God, you don't truly know how to be a parent. None of us was born with instructions on how to raise our children, but if someone had told them about the word of God, that should be plenty of instruction. My dad did what he knew how to do, and that was fight for his girls. He had ten girls that most people saw as beautiful. We did not see ourselves that way, and so we could not understand why our dad was so strict. I suppose he did not want us to be taken advantage of. He was stern, and we were fearful.

I didn't understand why people would call me stuck up, saying things like, "She think she's cute." All I heard at home was, "You're so ugly. Get out of my face, girl." This was our everyday living. I didn't think much of myself then; no one could convince me that I was cute, much less beautiful. Now, I know that God said we are fearfully and wonderfully made after his image.

People had no idea why we were so mean and hateful all the time, but it was because of our home environment. It made us hard and non-trusting. It made us put a shield up and not get close to anyone. My dad was very strict on us, and we were not allowed to go out and make friends. That was my father's way of protecting us from the wrong people.

I got married at the age of nineteen, became grownup before my time with grownup responsibilities. My husband always worked, even when we were teenagers. He got good jobs and worked hard. He also drank when we were young, and that became a strain on our marriage. He would go to work, and when he got off he would hang out with the corner boys. On Friday nights, he sometimes did not come home until the next day, and of course with very little money left in his pocket, sometimes none. He would come home and accuse me of liking guys that I did not know. He beat me up for something I did not know about or understand.

Oddly as it sounds, I remember locking myself inside the bathroom crying, talking to someone that I didn't know existed. Isn't it funny how we can call on God and not even know he exists? We hear other people say, "Oh God," not even knowing that he is really there listening and waiting for us to call on him for real. When we call on him, and really mean it, not just because it's something we heard or out of habit, but because we know him in the power of his might. His arms are stretched out wide. He's waiting for us to call on him with a repented heart. Remember, I was not saved then. I must have heard someone speak of a God somewhere at sometime. You know how people unconsciously say, "Oh my God, please help me"? At that time, I thought it was just a gesture.

I was beginning to think maybe my husband was crazy, accusing me when he knew that I was always home and that he was the only male person that I ever got close to—as far as I allowed, anyway. The Bible says, "Whatsoever a man thinketh in his heart, so is he" (Prov. 23:7). I could not believe or even think that he would be seeing someone else outside of our marriage; that was the farthest thing from my mind. He was the first person that I let come into my heart. I received love from this man, and for the first time someone embraced

me, hugged me, and told me I was pretty. It felt good to know for the first time that someone cared. You see, that was how Satan deceived me: he used what I hungered for the most to trap me into this marriage that was not ordained by God. It was my way of escaping from my home environment, or so I thought.

I got pregnant and had another baby, and another. Now I had three girls. My husband still was hanging out on the corners drinking; he would sometimes drink with my mother and my sisters. He went to jail for six months for something he did not do. I made sure I visited him every day I could. He finally got out of prison. By the time he came home, I was on public welfare, trying to survive with my three children.

He began to stay out again, but it was more than before. I did not understand his strange ways. Whenever he came home, he would bring friends with him, and they would go upstairs to the bathroom, come back down, and go out the door. One day we were sitting down with my sister playing cards, and I noticed these marks on his arm. I ignored it for a while, but one day he said, "I've been wanting to tell you something, but I've been afraid once I tell you, you would leave me."

I said, "I would not leave you. Just tell me what is wrong." That is when he told me he was on drugs.

My family and his family found out about it, and everyone kept telling me to leave him. They would say things like, "You need to leave him, or you need to find someone else. You are too nice and too good looking to put up with that. You can find someone better than that, someone that will appreciate you." My father-in-law would tell me the same thing. My mother-in-law would always say things like, "You shouldn't put up with that mess. I would not stay with a no-good man like that."

My mom never left my dad. At that time, I didn't know

about keeping marriage vows or the word of God, but my husband believed in "Till death do you part."

It got so intense that I couldn't take it anymore. I kept hearing what they told me, and finally I did leave him. When I did, everyone talked about me like I was the one that did wrong, after they made me feel so bad until I did leave.

Every night I would dream about a male friend that I knew when I was in high school. We really didn't go together. He liked me and I liked him, but I had a boyfriend, and that was all I wanted. All of a sudden, I started dreaming about him.

One day on the way home from my mom's house, I ran into him. He casually pulled beside me and spoke nicely. Satan sent him at the right time for me. My marriage was a mess, and I was in such a state of depression. I was trying to figure out what I was going to do next. He was married and so was I. What a mess! It was easier to make my decision.

I stayed with one of my sisters for a little while, leaving my home and everything in it. I was so naïve about life and about whatever was outside of my home and my home environment. I was not exposed to the ways of the world. Someone told me about a place I could live that I could afford, so I went to inquire about this place. Immediately I was placed into the projects. Of course I didn't know it was projects at the time; it seemed like a nice environment with lots of trees and green grass. We could actually sleep with our door open at that time. I didn't have sense enough to know I was surrounded by all kinds of bad influences. When I realized where I was, I told myself the same way I came in here decent with my children, that was the same way I was going to leave.

My friend and I started seeing each other, so now I was committing adultery. At that time, my husband got off drugs and went into the marines, and he was doing well. The timing was wrong for me because by then I was partying, going in

bars, and drinking. Satan sure has ways of deceiving us when we do not know him or his ways. Just like I didn't know God, I didn't know the devil was real, either. I started doing what I hated the most: drinking and committing adultery.

> "For that which I do I allow not: for what I would, that do I not; but what I hate, that do I.... For the good that I would I do not: but the evil which I would not, that I do."
> —Romans 7:16, 19

I remember my husband and I would always say how we didn't want to be with anyone but each other for the rest of our lives. I had meant every word of it. Even when you don't want to do wrong, you do wrong.

As I said in the beginning, my parents drank, so I grew up with parents that drank, I married a husband with a drinking problem, and now I started doing what I hated the most. It seemed as if everything was going well, or so the enemy set it up to look like that. Checks were being sent from my husband, so I was able to furnish and set my home up the way I wanted it. Before my husband went into the service, he asked me if I would wait for him. I told him, yes, I would. I did not keep my promise. I was still having an affair while my husband was in the service. It was an ugly feeling, hiding and sneaking whenever he would come home for a leave. I hated the sneaking around and lying.

Well, my husband finally got out of the marines with an honorable discharge. I was so proud of him. He never knew how I felt. In fact, my husband never truly knew me or how much I loved him, because I never opened myself up all the way to him or to anyone; I was afraid of getting hurt or disappointed. I watched my sisters go through such horrible pain, so I made up in my mind that I would never let a man

know my true feelings. I put up a shield and was always harsh and stern toward him. I didn't want to be like that, but I opened a door for Satan to come in to leave me with a hard heart. I wanted to enjoy him, but I wouldn't open my heart enough to get hurt like that. Even when I tried to be sweet and kind, I couldn't.

My husband came home from the service hanging with the same friends he had hung with before he left. Before long he was back into the drug scene. Then the day came when I was sick and tired of my life, my husband, and most of all myself.

Chapter 3

I Once Was Lost but Now I'm Found;
Was Blind but Now I See

M Y MOTHER-IN-LAW WOULD often ask me to go to church with her. One day I sat on the living room chair, looked up, and said to God, "If you are real like people say you are, then please change me. I don't like what I've become. Drinking, going into bars, smoking—it's just miserable. Change me if you are real." I hated myself and hated what I had becoming. I was in my early twenties.

I went to church with my mother-in-law one Sunday. I enjoyed the choir. One song that they sung stayed with me, and I'll never forget those words: "Give it to me, I'll bear it. Give it to me, I'll share it. If there is a need in your life, I'll take it if you only give it to me." I didn't remember anything that was preached. The Lord used praises of worship to draw me into the church.

I was not saved right away; I just was going to church but still drinking. It was time to come out from under the curse my mom unknowingly spoke upon my life. It crippled me, not just mentally but also spiritually. My mind was trained to think automatically that I could not do or be anything. I relied upon other people's talents and their gifts. Strangely

enough, I knew I was smart, but I would not demonstrate it because I was afraid someone would criticize what I did or what I said, not realizing that God blessed us all with gifts and talents. I was robbed of my self-confidence and my self-esteem. I didn't understand the ways of God.

I went to church one Sunday with a can of beer in my pocket. I couldn't wait for church to be over. It does not mean you are saved, just because you go to church.

The spirit of the Lord was drawing me, but I didn't know it. But one glorious day, Jesus presented salvation unto me. This day I went out with my sister-in-law and cousin-in-law to a bar that night. As they started talking to one another, I sat there. I happened to look up and something strange and unexplainable was happening to me. I looked up at the person that was serving the drinks. Instead of it being her face and body, it was my face and body I saw. I was dressed like a server with a low-cut shirt exposing too much of my body. As I turned to tell my in-laws what I was seeing, I could not speak; the words would not come out. I was deaf for maybe a few minutes. I then tried to get up off of that bar stool to put water on my face, and I could not move. As I began to get up, because I was so short, I had to look down to allow my feet to touch the floor. As I looked down before my feet touched the floor, I saw a large hole of darkness. I thought I was going to die right there in that bar. I knew I had not ordered anything to drink, so I couldn't explain why that was happening. Immediately the thought of my children came to me. What if I died in this bar. They would have to live the rest of their lives remembering that their mom died on a barstool. Immediately after that thought came, something inside of me cried out, "God, please save me for my children's sake." It had to be the spirit of Christ within, because I had never before heard the word "save" in a spiritual manner. Immediately the Lord answered, and I was able to move. However, while

I was sitting there, I did not see people anymore—I saw past people, and I saw demons. It scared me so bad that I told myself, "No more bars for me."

> "This poor man cried and the Lord heard
> him and delivered him from all his fears."
> —Psalm 34:7

To those who think God is just in church, that's not so—he is everywhere! He is omnipresent, which means he is everywhere at all times. Though we are sinners, Christ died for us. Praise God. Jesus walked among sinners and came to save the lost, to heal the sick. The well do not need a physician.

I got baptized and began to go to church, this time seeking the God that saved me in that bar. I was going to a Baptist church at that time. I enjoyed going to church and watching how the women conducted themselves. There was one elderly lady there that I kept my eyes on; she fascinated me because she looked so clean and holy. No makeup, no lipstick, nothing. But the beauty of the Lord shone so brightly on her countenance. She sang in the choir, and I loved to see how the Lord used her. I remember saying to myself, "I want to be just like that lady." She had such a glow about herself. I began to check my own appearance. I did not have any decent clothes to wear. All I had was tight pants and tight sweaters to wear. I started to buy nice dresses and skirts to wear. It was not her clothes to which I was drawn; it was the beauty of the Lord and the spirit that dwelled within her. I wanted what she had. I knew that I should not go into the house of God dressed that way; nobody had to tell me to change my way of dressing. The Lord used that sister as an example for me. I began to look at myself, showing all my cleavage, and I felt naked. It reminds me now of Adam and Eve in the

garden, when they ate of the Tree of Good and Evil. Their eyes were open, and they looked down at themselves and saw that they were naked; immediately they clothed themselves. I guess you could say my eyes were open. What I thought was innocent was no longer so. I thank God how he corrected me in love. The Bible says, "My son, despise not the chastening of the Lord; Neither be weary of his correction: For whom the Lord loveth he will correcteth; even as a father the son in whom he delighteth" (Prov. 3:11–12).

I started my journey seeking the God that saved me in that bar. I left the Baptist church and went to a Holiness church. I was growing spiritually, and I felt that I was not getting as much of what God had for me. Somehow I believed it was more to God than that. I was hungering and thirsting after the Lord. I went to church so much that my husband thought I was crazy, because he began to see the change in me; he didn't understand me anymore. I prayed all the time. I stayed up in my room constantly reading the Bible. I was shocked that what I was reading was happening to me in my life. I often stayed in the book of Psalms. The Lord started showing me my friends and how they were not my friends at all. People started turning against me. I stayed in the house. The only time I went out was to take care of my personal business and to shop.

Satan came against me fiercely at that time. The neighbors that I sometimes sat with started showing how they really felt about me. There was one lady with whom I had spent a lot of time; I would go over to her house a lot, and she would come over to my house, and we would sit outside in the summer late at night, talking and smoking weed together. My husband would always say, "That woman is not your friend." I never understood that until she turned on me. I thank God for opening my eyes at that time; he made it so plain.

One day when one of my sisters came over, she wanted

to go over her house, and she asked me to go with her, so I did. But when I went to step up on her steps, my foot would not touch the step; it just stayed up in the midair, and I could not move it until God spoke and said, "Do not go into that house." I thank God for his wisdom. He loves us better than we love ourselves. He is a friend that sticks closer than a sister or a brother.

These people were not my friends after all–they just wanted me around because I supplied the money, the company, and the weed.

I started seeing things in the spirit realm now, not in the natural realm. However, I did not understand it at the time. I would hear the Lord's voice giving me directions and the truth about people and situations. But because I did not know anything spiritual, I became confused. Satan was starting to be revealed to me in and out of the church.

I was so happy and full of joy, wanting everyone to experience what I had found. I wanted everyone that I knew to understand such love and joy that I had found. They didn't understand. "Oh taste and see that the Lord is good. Blessed is the man that trusteth in him" (Ps. 34:8). God began to do things for me that I could not explain. He was renewing the right spirit within me. My whole life began to change, including my way of thinking and my way of living.

I stopped smoking cigarettes and weed, and I stopped drinking—all at the same time. I remember when I was delivered from weed. My sister happened to come by one day, and she had no idea that I had stopped smoking. She said, "I have some weed, and it is pretty powerful. Here, try it." She told me to smoke only a little bit because I could not handle it. However, curious me wanted to see if it was as powerful as she said it was.

I tried it, but I just smoked a small amount. After a while, I began to hear two voices speaking to me. One said,

"Jump out the window." The other said, "Read your Bible and drink some water." That went on to the point that I found myself going to the window and thinking about jumping out. Then I got on my knees and I said, "Lord, if you take this feeling away from me, I will never do that again." Now that I sit here and think about it, before I got saved, I prayed this same prayer over and over again—but I had continued to do the same things all over again. God had known in the past that I just wanted some relief and would do it again, but this time he was dealing with me. My heart was being changed, and I really meant that prayer; God knew I was for real this time. I sat and read my Bible and drank some water, and the high and the voices left. Jesus and Satan were fighting for my soul. Guess who won the battle? Jesus always gets the victory! I never smoked weed again, and that was over thirty years ago.

"Whom the son set free, is free indeed."
—John 8:36

Chapter 4

Learning How to Trust Jesus

IT AMAZED ME at that time how God would answer my prayers so quickly. He would give me dreams and visions; sometimes I understood them, and sometimes I didn't. When I didn't, I would wake up and get down on my knees to pray and ask God to give me the interpretation of the dream or vision. Then I would go right back to sleep and get the interpretation. The things that the Lord would show me would happen sometimes the next day, sometimes later, but it would always come to pass.

I could not share these amazing wonders with my husband, because he was not spiritual and did not understand. That brought a wedge between us. The devil tried to use my husband to make me turn from God, by humiliating me in front of our neighbors. He would come home drunk and do some crazy and weird things that he had never done before. Our neighbors did not know him because he was in the marines when I first moved there. All they knew was that I had a handsome husband that they thought was good to me—which he was, whenever he was sober. When in the marines, he would write all the time and made sure our children and I were well taken care of.

I will never forget the exciting feeling I had when he had my wedding rings mailed to me. That was the first time I ever had a diamond ring; they were beautiful. He came home as often as he possibly could and would always bring a gift for our children and me. We had three girls at the time. Whenever he sent holiday cards for me, he would send each of his girls a card too.

While he was gone, I was learning to be myself and not what he wanted me to be. He treated me good, as much as he knew how. Where I lived, not too many women had husbands, so I was considered lucky in their eyesight. They never saw him like they saw him after I started serving the Lord. Satan came up against me through my marriage in such a way that I didn't know my husband after a while. But he couldn't stop me. It made me more determined, and I stayed on my knees more, crying out to God.

He would get drunk and drive his car up and down the road, threatening to kill himself. The neighbors had a field day watching his performance. They always looked for something negative to say about me and my family so that they would have some reason to smear my name. Somehow they knew I was different than the rest. I did my thing, but I never went as far as the rest of them. I kept my business to myself, and I kept my children close to me. That made others say I thought I was better than them.

One day I came home, and my husband was sitting in his car drunk with a friend, who had to drive him home so he would not get into an accident. I walked up to the car and saw him like that. It was hot and humid, and he looked so helpless. He was asleep with a cigarette in his hand; it had burned down to the butt of it, and it burnt the crotch of his pants. He had no shirt or undershirt on. My husband always made sure he dressed well. I got in the car after his friend left. I knew I could not wake him up in that condition, because he

was hard to wake up when he got drunk. I looked all around, and mostly all the neighbors were outside. I looked toward heaven and prayed, "God, please, in the name of Jesus, make a way for me to get my husband in the house without me being ashamed. Immediately it started to rain, and everyone had to go in the house. I looked at my husband and whispered, "Wake up." He opened his eyes and saw where he was and looked over at me. I said, "Let's go in the house." He got out of that car went into the house with no problem. As soon as we shut the door, the rain stopped and the sun came back out; everyone came back outside. God almighty let me know a few things that day. He cares, and he does listen and answer our prayers. The Scripture says he will make a way of escape for us. That increased my faith. I was astonished and felt so blessed that day. That wonderful feeling stayed with me for a long time.

> "Who shall separate us from the love of Christ? Shall tribulation, or distress, or persecution, or famine, or nakedness, or peril, or sword? Nothing shall separate us from the love of God." —Romans 8:35

I stood on the word of God and began to trust that the Lord would save my husband. Every time I went to church, the pastor would always pray for unsaved husbands. The saints would get up and give their testimony about how God had saved their loved ones. Therefore I began to trust the Lord for the salvation for my husband. I was in church on a weekday. The pastor would have tarrying service, meaning they would have the congregation go to the alter while someone said "Jesus" over and over in your ear as you repeat it. They said that was how one got the Holy Ghost. I did not understand because I was not getting anything from doing

that; neither did I understand what the Holy Ghost was. It made me feel uncomfortable.

After the service, I asked one of the sisters, "What does tarrying mean?" She told me that it meant wait. I asked, "Why aren't we waiting, then?" She looked at me with a puzzled look on her face; I had given her something to think about. I stayed puzzled about that because I wanted to be filled with the Holy Ghost. If they said I needed it, and the way they were begging God for it, I knew it must have been something good to receive. But I did not want to go about getting it that way; I just knew within myself that it had to be another way.

One day my sister asked me to go to church with her. I went to a church that was different than I had ever experienced. The preaching seemed okay, but after that, they had something called washing of the feet. They had pails and cloths to wash each other's feet. I felt very uncomfortable with that. Me, washing some stranger's feet? I couldn't even look my own family in the face and tell them I loved them. How was I going to wash this sister's feet? As I began to wash the sister's feet, she looked at me so softly and asked, "Do you have the Holy Ghost?" I said no. She said, "Do you want to be filled?" I said yes. I remember the excitement that I felt down on the inside as she told me to ask the pastor to pray for me.

I went to the altar. What a surprise it was that a woman prayed for me. I couldn't understand where she came from, because a male preached, but here came this sweet lady. I said to myself, "Oh my God, what am I going to do now?" Instead of running, I stood there as she prayed. It was not a long, drawn-out prayer; she prayed the prayer of faith, and others hugged me and said "God bless you," and I left the altar. I didn't have to repeat anything. People make God look like he's some spooked-out spirit that you have to go through

all these rituals in order to get something from him. He is awesome.

> "If I then, your Lord and Master, have washed your feet; ye also ought to wash one another's feet. For I have given you an example, that ye should do as I have done to you." —John 13:13–15

When I got in the house that night, there was no one there but me. Strangely as it may seem, it felt as though someone else was with me. I sensed a presence there that I could not explain. I thought someone was in the house, but there was not; it was a comforting presence.

> "Then laid they their hands on them, and they received the Holy Ghost." —Acts 8:17

The Holy Ghost is the comforter and the teacher. God let me know it was an answer to my prayer. Ask, and it shall be given; knock, and the door shall be open; seek, and ye shall find. We don't have to beg God for anything. He is a good God. All we have to do is ask believing, and it shall be given unto us.

I received the Holy Spirit that night in such a humbling matter. Later the Lord had revealed to me that he used that service of washing of the feet as an example of what God would do if we would just humble ourselves.

I did not speak in unknown tongues right away. The way God saved me was an act of faith on my part. I heard other saints speak in other languages over and over again. So many people would ask me the great question,; it was a spiritual challenge for me at that time. I believe it was a year later

before I spoke in tongues. But every time someone in church asked me if I had the Holy Ghost, I would hear God's soft voice whisper say yes. My faith was being tried, and I needed to know God answered that prayer without the evidence. Unknown tongues is just the evidence that the Holy Ghost is there; you don't always have to speak in tongues to prove to anyone that he is on board. So by faith, I believed that I had that experience, even when the devil said it didn't happen. I could not deny what I had experienced that night. From that day on, I began to walk in faith, knowing that I was truly filled.

> "Then laid they their hands on them and they received the Holy Ghost." —Acts 8:17

The next time they had altar call, the pastor told us to tarry, and another wonderful thing happened to me. The Lord spoke to me with an audible voice and said, "Do not clap, do not say anything. Just stand here." I did just that. As I obeyed God's voice and stood there, I felt a warm sense come down from heaven and cover me on every side. It was as if I was hedged in from the top of my head to the bottom of my feet, as well as on each side, front and back, as if it was an ark of safety. A soft, wonderful voice spoke and told me, "I'm going to give you wisdom, and I'm going to save your husband."

I was so astonished that I could hardly sleep that night. I was excited that I had heard the Lord's voice speak to me audibly like that. I never prayed for my husband's salvation after that, because I trusted God and stood on his promises. That was 1976. My husband is now in heaven with his heavenly father; he accepted Christ and now is home, resting in peace. God is true to his word.

"And being fully persuaded that, what he
had promised, he was able also to perform."
—Romans 4:21

I continued to attend that church until the Lord started showing me things that was not of him. I began to listen more attentively and was watching as well as praying. The church would have different programs to raise money, and I did not approve of that because I believed if one asked anything, one should believe it would be done. I believed that God had other ways to bless the church financially without begging or robbing God's people of their money.

There was so much pressure on me trying to make ends meet, paying my tithes with very little income. I was still on public welfare, giving everything I had sometimes. I did not have food for my babies. My husband had went back on drugs. He was stealing money, food stamps, and even the tithes at one time. I went to the pastor to get help, telling him what my husband did. All he said to me was trust the Lord.

I remember one time I didn't have food for my baby to eat, and I did not know where I was going to get it. The next morning I went down to check the mail, and there was a bag of baby food on my doorsteps. I was so excited that God was looking out for me; he knew my heart and knew I was trying to obey his word by faith. He always came through for me.

Chapter 5

My Sheep Shall Know My Voice

ON SUNDAY BEFORE the sermon, the church would have tithes and offering time. We would form a line, and they would read the word of God. "Will a man rob God? Yet ye have robbed me" (Mal. 3:8). At that time, I was a baby in Christ. I could not understand why I could not comprehend the word when I read it. I trusted what the pastor was saying. Some Christians will use the word of God to control you if you are not in tuned with the voice of the Lord and do not know him for yourself.

I became fearful, trying to obey the word of God to the best of my ability. Confusion began to overtake my mind. I was hearing from God and listening to the pastor, thinking, *He is a man called by God; he wouldn't say anything wrong.* The zeal and excitement made me vulnerable. I was afraid not to pay my tithes. God wants us to be cheerful givers. Some pastors use the Scripture to make the saints do what they want them to do.

I was not able to determine whether it was the spirit speaking through the man of God, or the man speaking. I became confused because they started asking for more than just tithes. They made the members feel guilty if they didn't

have money for all the other offerings that the church was expecting from the members. God required us to pay our tithes, not all these other offerings for which the church ask us. As I continued there, I did not agree with what was being said or done. God allowed me to sit and learn some things. It was difficult remaining there while the Lord was revealing things and not being able to share it with anyone. I tried, but the sister that I tried to tell looked at me as if I was crazy.

I remember going to prayer service, which we had at a sister's house that night. I was waiting for the bus at the bus stop, and a lady came up to me to ask a question. As I began to look up, she was behind me, getting ready to put her hands around my neck. Immediately I felt the power of God push me forward and out to the way. When I got to the house of prayer, surprisingly the Lord had a word for me. It amazed me how God sometimes used my enemies to give me a word or a blessing. The pastor unusually went into the word of God that night. By the time I got there, the prayer was almost over. After prayer he read 1 Corinthians 13:1: "Though I speak with the tongue of men and of angels, and have not charity, (Love) I am become as sounding brass, or a tinkling cymbal."

The pastor was trying to raise money for a building because we did not have our own building. Therefore he began having services at different churches, and having different churches come there to raise money. It was called money swapping, and that was not of God. That was doing it themselves and not really trusting God to take care of the household of God. They would have weekly revivals to take up offerings. I used to get so excited when the church would call for a revival, thinking, *Oh my God, the Lord is really going to move tonight*. The Lord moved, all right—he moved from there to a place where his people really wanted true revival.

That was not what revival is about. True revival is a real

move of God, when he comes in like a mighty rushing wind and makes some eternal changes on the inside of us that nobody else can do. God said, "My people praise me with their lips, but their hearts are far from me." If we really want to see a real move of God, God says, "If my people, which are called by my name, would humble themselves and seek my face and turn from their wicked ways, then shall they hear from heaven, and I will heal their lands." God call preachers to preach the word of God and to teach his people how to get to him and learn his ways. He said, "Freely we receive, freely we give." Sure, the word of God tells us to pay our tithes and offerings, but we should not have to pay to hear the word of God. Salvation is free. All God asks from us is our hearts. He wants us to turn our hearts back to him, to get us out of the mess that we made of our lives. We should undo what we did and turn wrong back into right.

They were selling raffle tickets for a women's day breakfast, and I did not want to sell any tickets. When I went to service that Tuesday as usual, prayer began, but the pastor and his wife were not there yet. As I proceeded to get on my knees, the spirit of the Lord told me not to pray but to sit there and read my Bible. When the pastor came in the room, he noticed that I was not praying. I think he had it out for me before he got there anyway, because after prayer he got up and said, "We have some folks that did not take any tickets to sell, and if you can't sell any women's day tickets, then you're not a woman." When I heard those words, it felt as if someone had stabbed me in my stomach. I heard the voice of the Lord say, "Get up and leave." By then I was shocked and didn't know how to leave, because I figured if I just got up and left, the congregation would think that I was being used by the devil and was fighting against the pastor. Then I heard the Lord speak again, but in a much sterner voice. I got up and I began to walk toward the door. At each

step I took, the pastor said, "Praise the Lord." The third time he said it very loud, and the congregation repeated after him, louder: "Praise the Lord!" I felt so hurt and so sad as I walked out of the door.

I remember saying, "Lord, please forgive them, for they know not what they do." Of course they did not know what the Lord was telling me. I stayed home for a while, not attending any church, until my neighbor and I were outside talking, and a friend came by. My neighbor introduced me, and we began to talk about the Lord and what was troubling me. She said I was having a hard time because I had a calling in my life. I had no clue what she was talking about, and she invited me to her church.

I went to church that Sunday; it felt good being in church again. I heard that the former church I had attended had moved into their own building. I thought it was okay just to visit. That was crazy! I went one Sunday. I was so happy thinking that the Lord was going to bless me, but instead of the Lord blessing me, at the end of the sermon I heard the Lord's voice speak to me in an audible voice, saying, "I did not send you." I was so shocked and so ashamed that I disobeyed the Lord. When I went home, he spoke to me again but not audibly this time. He said, "They that worship me must worship me in spirit and in truth."

Of course I did not understand again, so I called the pastor of the church I was not suppose to go to. I was desperate, wanting to know what God was saying to me. I told him how I had been experiencing the Lord's voice. He said, "Be careful, sister." That left me even more confused. I thought he was going to rejoice that I was hearing from the true and living God. How naive I was.

After a period of time, the Lord started dealing with me again in dreams and visions about what I had experienced at that church. God gave me a vision of the pastor going to his

grandmother to receive the oil that he was putting on our heads to anoint us with, and how his wife was sitting on a table counting the money that they received from the people. I always wondered why the oil would burn my head and why it had an aroma. His grandmother was putting something in the oil that was controlling our minds to think the way he wanted us to think. If you know anything about witchcraft, that was one form of it. I pray that this book does not scare you from serving God but enlightens you on Satan's devices. I want you to get to know God for yourself. That's my reason for putting this part of my experience in here. I pray that God will protect you as you read further on, because Satan does not want the truth about the kingdom of darkness being exposed. However, God said he would not have us ignorant, so here I go again, trying to pursue the Lord that I met in the bar.

I received such love and mercy from him, and I was trying to find the same love as I went from church to church. I did not understand why I could not find someone that heard his voice like I did. The fear and the respect were not being displayed, and as I continued to go from church to church, I realized that something still was not right. I went to church sometimes every day. My husband was frustrated with me because he did not understand the mercy I received and how desperate I was to serve my wonderful savior. I thought everyone else felt the same way I did. It did not seem as if the saints of god respected or feared God as I knew we should. I thank God for the way he revealed himself to me; it made me determined no matter what I went through in this walk. I would not give up neither will I ever turn back. I became uncomfortable at that church also—it did not seem right.

I was able to bring my children up in the Lord. We would read Scripture, sing hymns, and pray each night before we went to bed. I had three girls at that time, and I wanted a son

so badly that I began to pray and ask the Lord if he would bless me with a son. My mom had ten girls and two boys, and everyone would tease me and say I should give up, or I would be just like my mom. My mom's first child was a son, and after that she had eight girls before another boy came along. The power of what was spoken gripped my mind, and I just knew if I prayed, God would grant me a son.

I got pregnant, and what do you know, I had a son. I was so proud and happy; I remember as if it was yesterday. I would walk down the street and say to myself, "I can't believe I have a son. God is so awesome." Not only did he grant me that son, but he blessed me with another. Now I have two sons and three daughters. I'm thankful, and I'm proud of my offspring.

As I continued to attend this church, they began noticing my gifts. God had not yet revealed my gifts or my calling to me yet. The church told me I was called to preach the gospel, but I was not ready for that yet. I did not have knowledge of God, nor did I know him to do a work for him like that. I feared God and I didn't play around; when it came to doing a work for him, I took that very seriously.

I sought healing because I was sick in spirit, mind, and heart. I needed a real physician, Christ Jesus, to heal my mind, soul, and spirit. I needed God to clean me up and show me how to live for him, before I could do anything for God. I was serious and meant business. I needed deliverance, not a title or position in the church. I needed to do just what the Bible told me to do. Jesus said, "Take my yoke upon you and learn of me. Because my yoke is easy, and my burdens are light" (Matt. 11:29).

I stopped going to church as much as I did at first. My husband kept telling me that there was something wrong, and he did not want me going there anymore. I did not stop going right away. Then my stomach started swelling, and

I stared wondering why every time I would tell the pastor about the things the Lord would speak to me about, he and one of the saints would look at each other and get quiet. They finally shut me out completely. I remember at Christmas time I was sitting in my living room and watching my husband put together the Christmas toys for the children. He was drunk, of course. I stayed to make sure he was doing it correctly. All of a sudden he looked up at me and said, "Beware of false prophets." Then he continued to do what he was doing, as if he had never said anything. I knew not to question him—he had no idea that he said it or why he said it. All I knew was that God spoke through a man that was drunk on alcohol. God went right past all that and spoke a word to me. Who can figure out the mind of God? He is awesome. I quietly ran up the stairs, went into my bedroom, shut the door, and prayed to my father for understanding. I was afraid, not wanting to preach because I knew God was not dealing with me about that at that time. So many people got messed up and harmed not just themselves but a lot of other people. I needed to seek God and find out if he was calling me into ministry, and if it was my time to be used by God. "Wherefore the rather, brethren, give diligence to make your calling and election sure: for if ye do these things, ye shall never fall" (Pet. 1:10).

I was troubled all night, and the next day I called one of my sisters in Christ that I knew was hearing from God. I told her what had happened; I also told her about my stomach and how it swelled up so bad every time I went to church on Sunday. The pastor would cook and invite some of us to dinner. I enjoyed his fried chicken. Whenever I stayed out of church, I had an unusual desire for his cooking. I would ask one of the sisters to bring me a dinner after church, and she did. I started noticing my stomach swelling up unusually big. I also told her whenever I would tell my baby to say, "Thank you, Jesus," he would cry.

My sister in Christ, who also was my prayer partner, came over. We began to pray as the spirit of the Lord came forth. He began to break the power of darkness, which was Satan. I told my baby to say, "Thank you, Jesus," and he said it with a loud and triumphant voice. He was only two years of age at that time.

The next day the Lord gave me a word in my spirit. He said, "Follow after the spirit, not after the flesh." Again I didn't understand, so I called my prayer partner and told her what the spirit of the Lord spoke. The Lord used her in prayer to give me understanding. I went to another church still seeking to hear from God for confirmation. When I got inside, I was expecting something different. Instead it was the same as the rest. They had altar call, and of course I went up to the altar for prayer. As I was standing there, I saw that they were tarrying with the people, just as they did at the other churches. I could not figure out how I was going to get out of that line without somebody saying anything to me.

Suddenly it seemed as if the spirit of the Lord turned my head at the right time. As I looked up at the wall, there was a sign that said, "Fight the good fight of faith." I got excited because I knew God had made a way of escape for me, even though I disobeyed him again. A certain kind of boldness came over me, and I did not care what the people thought. I went back to my seat, and when they asked if I could stand up and say something, I stood and said I was saved, sanctified, and filled with the Holy Ghost. I said it very quickly, sat down, and said to the Lord, "Thank you." I was hoping they did not ask any other questions or tell me they saw some kind of gift. I stayed home and made up in my mind that I was never going to church again.

My biological sister called and said, "You have not been to church—you are going to be in trouble."

My response to her was, "I'm so glad the church is in us,

not just in the building. If you know like I know, you'll get out of there too." I stayed home vowing that I would never go to church again. I was sick of going to church and falling into the same thing over and over again. At one time my sisters and I went to the same church. The pastor at one church we attended told my sister she had some nerve taking up space and using a chair for which she did not pay. At the time we were going, they did not have a building and were taking up offerings to buy chairs for the new building they had purchased. When she went to church at the new building, she was not welcome. The pastor told her she was not saved because she didn't attend services like she should. My sister stopped going to church completely and went back into some of the same things God had brought her out of.

But Glory be to the most high God, she is back where God would have her be, being used to draw others to God's love.

> "Feed the flock of God which is among you, taking the oversight thereof, not by constraint, but willingly; not for filthy lucre, but of a ready mind. Neither as being lords over God's heritage, but being ensamples to the flock. And when the chief shepherd shall appear, ye shall receive a crown of glory that fadeth not away." —1 Peter 5:2–4

Chapter 6

Learning about the Mysteries of God

I STAYED HOME AND did not go to church. I never stopped serving God, and I never went back into the things he brought me out of. I still prayed and sought the Lord; he always showed up on time. Many Christians think if you do not go to church, you are not saved anymore, but that is a lie from the pit of hell. Once you accept Jesus Christ as your personal savior, you are saved, and he writes your name down in the lamb's book of life and remembers your sins no more. He is married to the backsliders, meaning no matter what you have done, it is never too late to repent and ask God's forgiveness. I am not saying that you should not go to church, but pray and ask the Lord to lead you to the church that he wants you to attend. You will not go wrong when you're led by the spirit of God. The word of God says that we should assemble ourselves together even more so as we see that day approaching. Therefore I decided to stay home and serve God at home.

That was fine for a while, until one morning my sister woke me up, calling and asking me to go to this church with her. I had just had a vision of a cross coming toward me; it started out being a small cross, but the longer I looked at it,

the bigger the cross grew. It was a beautiful cross, and I did not understand that vision, but somehow I knew it was time for me to go back to church. I had been praying asking the Lord to send me to a church where his spirit dwelled, where I could be spiritually fed.

What impressed me was that my sister said, "You know how the Lord gives you dreams and visions? Well, this pastor preaches about how God gives us dreams and vision. He even tells them that God spoke to him in an audible voice."

I got dressed and went to church with my sister. I went again, and again, and again. To my surprise the Lord used this pastor to bring understanding and clarity to me regarding the things that I went through and why God allowed me to go through them. I learned much; that's all I will say about that.

With the excitement of being in the presence of God, I could not wait to get to church. Someone would pick up those that needed transportation. I was not used to that. In the former churches I'd attended, we never got transportation. I was pregnant with one baby and had three little ones beside me. The former pastors would ride right past and not offer a ride. There was one incident after an all-night prayer. At 5:00 AM we were walking early in the morning; we lived far from where the church was. My sister asked the pastor, "Aren't you going to give my sister a ride? She is having a baby." He gave me a ride and rode right past her with no remorse. We were so excited about the Lord that we would walk to church no matter how far the church was. I was not used to being picked up from my home and being taken back home. We were never asked for gas money, which I didn't have anyway. This was real and this was how God wanted us to treat one another.

I had also had a bad feeling about paying my tithes. I knew in my spirit that the tithes and offering was not

supposed to be spent for the pastor's personal use, as I spoke of in the other chapters of this book. God was answering so many questions through this ministry. One Sunday I went to church, and the evangelist called someone up that was not even a member of the church. The man said, "The Lord told me to bring my pay for this week, and I did not know why, but he just told me that you have a need. Your phone and your electric is about to be cut off." He reached into his pocket and gave her his paycheck for that week. I was so excited that I almost blurted out, "I knew that is what the tithes and offering was for!" Besides taking care of the pastor that is called into full-time ministry, we should give offering to the ministry that it would grow for the glory of God.

When I say to take care of the pastor with full-time ministry, I mean those that are God-called to dedicate their lives. Those are the ones that God set aside to seek his will for the ministry and for the people. It's not about taking the money and buying big cars and fancy houses. That is not why we pay our tithes and offering. It should go in the ministry for the upkeep of the house of God, for the building of the kingdom of God. We should be able to go to the church and get help. The church is supposed to be a refuge, a safe haven for God's people and for those that are seeking to be saved and set free from the hands of Satan. It's not a place where you go and the church makes merchandise of God's people.

The pastor at this church had an old car, and he lived in the church. It was hard to get him to spend anything on himself. He would go to God to ask if he could treat himself out for dinner. That impressed me. *This is real*, I thought. God sent me to a true man of God who was concerned about souls. It was so important to pray and ask the Lord for directions to the place he would have me be. A lot of innocent saints didn't know that Satan set up churches too. God taught me the difference in serving God and serving the

flesh. The man that was supposed to be representing God, I realized, was not serving God but was serving man, and it hurt me to know that after all Jesus did for me. The way he revealed himself to me—and not only that, but thinking about him dying on the cross and suffering for us the way he did—made me think I was serving him, but instead I was serving man. It is easy to get caught up like that if you don't study and know that word for yourself. God allowed me to experience all of that so that one day I would be able to tell someone else to look to Jesus for direction. Jesus will never fail you. Learn his voice and his ways for yourself.

I began to learn about spiritual warfare, the fight that came in the spirit realm, the mysteries that only God can reveal. The Lord opened up my discernment. For those who don't know what discernment means, I'll bring it in the natural way that the world knows it: it's like someone saying she had a bad vibe when a person walked past, or when she went into a house. That's God's protection he gives us. What most people don't understand is that there are two spirits in the world. There is the spirit of God, and there is the spirit of Satan. It's good and evil. We are motivated either by the spirit of God or the spirit of Satan: either you feel good vibes or bad vibes. In this spiritual walk with my savior, I found out that there are demons and spirits that Satan assigned to those for whom God has special work. "So the last shall be first, and the first last: for many be called but few chosen" (Matt. 20:16).

God's timing was awesome. He sent me to the right church at the right time. My pastor taught us well about spiritual warfare. I started feeling evil spirits whenever I would be in certain places or be around certain people. If I was not in the right church where they were teaching the word of God, I would have thought I was losing my mind. However, the Lord taught me to pray when I first got saved.

I always prayed no matter what. People would make fun of me and say that all I did was pray.

My one-year-old grandson came down the stairs, seeing me on my knees and praying, and he said the same thing: "All she does is pray, pray, pray." Then he went back up the steps. I laughed and thought, *He'll remember to pray when he gets older. Little do people know that prayer is the open door for God to come in.* How did they think they developed a relationship with him? It came from praying and communication with the savior.

I learned that demons trembled at the name of Jesus. It was one thing to read about it in the Bible or hear it preached, but it was another thing to actually experience it for myself. I realized that the word of God was real. It blows my mind how you can read exactly what you are experiencing in the natural and spiritual world. It is definitely a guideline for living. The pastor would say, "Seek the Lord's saints," and I would fast and pray, not realizing that reading the word of God was also a part of seeking him. He speaks to us through his word; we cannot make it without it. Jesus said that man cannot live by bread alone, but by every word that proceeded out of the mouth of God. It is the light leading you out of darkness.

I loved the preaching and the teaching that I was getting at this church. At one service the pastor called me up for prayer, and he said, "I opened up your tithes envelope and felt a spirit of fear fall on me. The Lord told me you were paying your tithes under a spirit of fear." I knew that was the Lord talking to me, because I was afraid not to pay them; the pastor at the former church would say that there would be a curse on top of a curse if we didn't pay our tithes. This pastor went on, saying, "The Lord does not want you paying your tithes in fear." That night we went home, and I asked the Lord to deliver me from the spirit of fear. I also asked

him what I should do. I wanted to give from a cheerful heart as the Bible told us to. So many of God's people were being taught the word of God incorrectly. They did not know how to seek him for themselves. Some people thought it was wrong to ask God questions. I want you to know that you can ask God whatever you need to know, and he will reveal his word. "The heart of him that hath understanding seeketh knowledge: but the mouth of fools feedeth on foolishness" (Prov. 15:14).

You can develop that kind of relationship with him. The Lord told me to stop paying my tithes. I was feeling very uneasy about that until I realized he did not allow a curse to come upon my house. When I saw how the pastor was helping the people financially with their bills, or whenever the people had a need, I felt something inside me leap. God was answering prayers speedily. He taught us faith that I had never seen before. Many preachers preached about faith and believing in God for everything, but when the test came, they really didn't have what they said they had. This pastor not only preached it, but he also lived what he believed. He gave great testimonies on how God healed his cancer and saved his life from so many other sicknesses. He gave testimonies about God using him to raise the dead. He preached faith, and God came with signs and wonders to follow.

I developed a bad toothache, where my gum was overlapping my tooth. It was painful, and I always feared going to the dentist. I started thinking about the testimonies that the pastor gave, and I made up my mind that I was going to trust God for healing. I wanted to rely on the word of God. The gum swelled up so badly that I could not eat and had to sip out of a straw. I laid on the sofa crying because it was so painful. My husband did not understand why I was not going to the hospital, and he was angry with me. He asked me whether I just liked pain and suffering.

One of my sisters came by that I had not seen in a long time. My faith was being tried. She begged me, "Please come and go to the hospital. I will go with you, and we will get a cab. I will pay for it."

I said, "No, I am believing and trusting God for my healing."

I had been hurting for two days. On the third day my pastor called and asked me how was I doing. I said, "Hurting, but I'm trusting God."

He said, "The Lord said today is your day. He is going to heal you at twelve o'clock, God bless you, sis." Then he hung up.

This was my day. Twelve o'clock came, and the spirit of God came upon me. The Holy Ghost touched my gum, and from that day I have never had a problem with that tooth again, or any other tooth. That was over twenty years ago; the gum is in place no swollen. I didn't have to go to the dentist to get a needle or to pay a bill. It was healing, free of charge. As I was getting my healing, one of my neighbors who was saved came by. She knew the pain that I had endured, so she came to beg me to please go to the hospital right in the midst of my healing. She must have thought I was speaking some other kind of language she didn't understand—which I was. But if you are a Christian, you should know the moving of the Holy Spirit. She even stated that poison was going to go throughout my body. While she watched in disbelief, I was praising God and rebuking her. I did not understand Christians that did not believe in healing. They always quoted Scripture, yet they did not believe or stand on the word of God. God blessed me with greater faith. Jesus said in his word, "Let no man take that which I have given you." I was not going to let anyone take my faith away from me. God healed me right in her face, and she never knew it. One can miss Jesus by not believing.

51

Chapter 7

Discernment without Compassion

ONE HAPPY, EXCITING day I decided to give a testimony. I stood up and told the church that God had spoken to me with an audible voice. I also told about other experiences I had had in the other churches. The pastor and some of the other saints started treating me differently—I noticed they started shunning me. My sister would walk in the door and get a holy kiss, but they would walk past me. It kept happening, and I began to get sad. There were some saints that saw me as someone that wanted Jesus. Whatever the pastor discerned about me, I had no knowledge of it. I didn't understand the gift of discernment then; I came in with whatever spirits I'd picked up from the other churches from which I'd come. Now I understand, but then I didn't. The pastor had an unusual gift that I had never before encountered. He would pick what type of spirit a person was as soon as one entered his presence. He began to preach about a divination spirit, which of course I didn't understand.

People started shunning me and not speaking to me. It hurt because I thought I'd finally found a place where I could serve God in spirit and in truth. It became hard to endure, and I would hear the enemy in the midst of the sermon

say, "Leave and don't ever come back here." Sometimes I would walk out. On my way to the bus stop, my sister would come after me, begging me to stay. She told me, "The Lord's presence is here, and the devil don't want you here." I knew that, but I couldn't bear too much persecution. The service was good, and I didn't want to miss out on my blessing because I knew God had sent me there. I went home, got down on my knees, and prayed. "God, why? What have I done? What is it about me that I can't see?" I didn't go there to be used by Satan. Everywhere I went, I was treated like I was an instrument of Satan. As I began to get up, the Lord led me to the word of God. Before I could turn the pages, my answer was right there on the first page I read: "Because they know not that the Spirit of God rest upon you." I sat there crying for a long time. I could not believe that God loved me so much that he would reveal that to me. It was right there in his word.

I wanted to tell my husband what I was going through. The spirit of the Lord spoke to me and said he would not understand; it would cause him to turn bitter toward church and the people of God. Therefore I kept it between God, my sister, and myself.

I began to learn the difference between the spirit of God and the spirit of man, between God's voice and the voice of the flesh, which was man. I loved the ministry and the teaching with which God blessed the pastor. He was unique and different, and I understood that he had a great love for God. He also had a great love for the people that God placed in his hands. He protected the flock, but sometimes his flesh got in the way. His spirit reminded me of my biological father: how he protected his children—the love of the flesh without compassion and understanding. "And though I have the gift of prophecy, and understand all mysteries, and all knowledge; and though I have all faith, so that I could

remove mountains, and have no charity,(Love) it profiteth me nothing" (1 Cor. 13:2). As I continued going, I realized that the pastor thought like I did. He was discerning the spirit of divination that followed me from the other ministries. I supposed he picked it up when I said that God spoke to me with an audible voice.

He didn't believe God ordained woman to speak or preach the word of God. Little did he know I didn't wanted no part of that, anyway. As strange as this sounded, he said God spoke to him with an audible voice. So I figured that maybe I was of a divination spirit. As I stayed and listened and paid attention, I realized that he too was hurt by the church before he began his own ministry. The pastor didn't realize that I was still under demonic forces and needed deliverance.

We must learn to be prayerful and guided by God's spirit. Be careful how we treat one another. "Let brotherly love continue. Be not forgetful to entertain strangers: for thereby some have entertained angels unawares" (Heb. 13:1–2). After all God show me in the Scripture, I became afraid again. I called a prayer hotline and began to tell the sister that answered the phone what I was experiencing. She was sweet and patient, but she herself could not comprehend how God was dealing with me. She put a brother on the phone, and again I began to explain to him the same thing I'd tried to explain to the sister. He started praising God and got very serious. He said, "Sis, don't you ever let anyone tell you you're not hearing from God. That's the Lord's voice, and you have a special calling upon your life." He prayed the prayer of faith, said, "God bless you," and hung up the phone.

I thought, *How does he know, and what do I do now?*

That same soft voice spoke audibly again and said, "Trust and believe." From that day on I didn't doubt God's voice; I just started keeping those kinds of testimonies to myself.

I still didn't believe in my calling because I couldn't get past what the pastor had preached about women preachers. The Lord started using me to pray for others and to speak a word in others' lives. I dared not share it with the church. I prayed and asked God to reveal to me the calling that the brother spoke of on the phone. That very same night I had a vision of myself lying on this step, across from the church that I attended. In the dream I felt like an outcast from the way I was being treated. I saw the people coming out of church going to dinner, but I was not invited. I laid on those steps in this vision, feeling so badly.

As I looked up, I saw this beautiful bronze door. On the door it read "Prophets." A female prophet came to the door and said to me, "It is not time for you to come in yet." I remember that vision as though it was yesterday. I remember the lonely, sad feeling that I had at that time. You see, when God speaks to you one on one, as his servant you cannot make people understand or know what God is doing in your life. I learned the hard way that we have a personal walk with God. It should be a personal relationship with him. God doesn't reveal everything to the man of God. Sometimes you must seek him for yourself. You have to trust that God will walk you through these things and give you understanding in his own good time. The word of God tells us to let every man work out his own soul's salvation with fear and trembling. As I sit here and type these truths, I feel God's presence still delivering me from the past. I will go forward and do what God called me to do. Almighty God does not have to get man's permission to call his servants to go forth and tell others about his goodness. "God forbid: yea let God be true, but every man a liar; as it is written, That thou mightest be justified in thy sayings, and mightest overcome when thou art judged" (Rom. 3:4).

Yet the pastor had an awesome ministry. The way the

spirit of the Lord would be in the midst was unbelievable. I could actually see the glory cloud in the midst. We would go in shouting, crying, and praising God, and we'd come out shouting and praising the Lord. It was such an amazing thing, to see God using a man like that. God used him to heal the sick, set the captives free, cast out demons, and give the plan of salvation. I actually believed that he was the only preacher who had the true spirit of God walking with him. I would not go to any other church, because I would get the same garbage I'd got before I came to this church. I had never seen a pastor so concerned about the saints of God like I'd seen here. He would get up out of his bed to pray for anyone that called, no matter what time of day or night. I would never forget when I called for financial help, and the pastor came and bought me money to help with my bills and bought groceries. It didn't matter who needed help; he was there. He enjoyed picking up the saints for church.

Chapter 8

Learning the Love of God

I SAW THE PASTOR as a great, anointed man of God, which he was, but he lacked (as all of us do). What he lacked was the love of God. When you haven't truly tapped into the love of God, it's easy to love those that love you, or to love those that always agree with you no matter what you say or do. However, the true test comes when you start launching out in the spirit, and God starts taking you through things that man doesn't understand. I began to go through a personal journey with the Lord that even I didn't understand.

The Lord used the pastor to give me a message. While in the spirit, he spoke to me, saying, "Sis, the things you're going through God is going to use you to help many. The things that I had to experience brought about a great deliverance. I was set free from things that were in me and that even I didn't know were there. He purged me from a self-righteous spirit, a judgmental spirit, and a religious spirit. I started doing things that no one else could tell me I would've been doing. However, every time I went to God in prayer and looked for hellfire or destruction, or to be cut off from God, instead I received love. He would just wrap his loving arms around me, comfort me, and encourage me. When I was tormented

by the devil and felt so unworthy, that was when God, with his unconditional love that passed all understanding, would send his anointing and break the binds of the wicked one. The pastor did not understand, and I could not explain to him what was happening to me.

However, my biological sister and I had a wonderful relationship because of it. The Lord used me to lead her into salvation, and we became inseparable. She also became my prayer partner. She understood what I was going through because she was going through some of the same things. She too experienced the true love of God. It was an awesome thing to have a loved one walk with me in the spirit. We knew each other well. We suffered with one another, and we also rejoiced with one another. She would call me every night to say good night and to say "I love you." I thanked God for her. At that time, I needed her and she needed me. The pastor didn't understand our relationship because he would always say we were binding each other up from getting to God. However, little did he know God was using us to help each other get to him. When it was time to seek the Lord for ourselves, we knew it was time to separate ourselves from one another. We never hindered each other from getting to God one on one. She would always say, "It's time for me to go before God, and I'm going to shut my phone off and not answer the door, just in case you don't hear from me." We both did that with each other. We knew how to seek, and we knew how to humble ourselves, turn our plates down, and seek God's face. If I did not know how to pray and let God lead me with his infinite wisdom, then I would have missed God's blessing through my sister. I think about the Scripture that says what God put together, let no man put asunder. I don't believe that just counts for marriages. God joins people together so that they can help each other make it to the next level. God knows just what we need, and at that time, it just happened to be my sister.

My sister would come out of nowhere and say, "I'm going to be with Jesus, and you are going to still be here." Then she began asking me if I would take care of her grandchildren if she was to leave this earth before I did.

The day came when she was gone. She was no longer there for me. She would often say, "I'm tired. I'm praying and asking the Lord to take me home. It's not going to get any better down here; it's going to just get worse." The Lord answered her request and took her home. She was in her forties. She withstood more than I could ever withstand. However, she never stopped loving and praising. One day she had a massive heart attack, and she was gone before I made it to the hospital. Everyone was looking for me to fall apart. I didn't fall apart, but it affected me in a way I didn't expect. My back was hurting so badly that I couldn't lie down, sit, or even stand. It almost made me immobile. Of course demons were hanging around like they usually did when death came. I couldn't go to pick out her attire like she'd asked me to, so that made me feel pretty bad, but that didn't matter to me after awhile. I was glad God lifted me up and gave me strength enough to make it to her home going. The enemy was hanging around, saying, "She's gone now. What are you going to do?" He was saying, "Ah ha, you don't have your sister to talk to, listen to, or pray with you anymore."

My sister was in heaven, still being used by God. When I needed correction, the Lord used her in my dreams to give me a word from him. I didn't lose my sister—she just became one of the angels that God chose to war on my behalf. I thank God for answering my sister's petition. God knows just how much we can bear. He has his appointed times for people to go home; that was her time.

Now I had to lean completely on God and him alone. He would never leave or forsake me. Years later, after a service I found myself talking to some of the saints. I heard the spirit

say, "Look up." To my surprise I saw that very same beautiful cross that had been in my dreams. It was built into the wall. I never noticed the cross all those years I attended there. The Lord blew my mind. After all those years, he gave me confirmation without doubt that he sent me to his house.

I started getting a desire to go back to school, so I went to school while I was on public welfare. There was a program that sent me to different places to do volunteer work. In the morning I went to school, and in the afternoon I did volunteer work. After work I took up a typing class. Before I knew it, I had a job. I'd never had any experience, and I didn't finish the classes that I'd started, but I was hired. I didn't have any computer skills, but I did have good customer service skills. God taught me how to respect and be kind to others. I worked with what I had. I knew if I had the right trainer, I would do well. The Lord gave me favor with the office manager; he hired me before he could even interview me. After that he was gone. It was difficult in the beginning because the person he assigned to train me was mean and did not want to train me; she would keep answering the phone and not talk to me at all. I had to pay close attention to what she was doing and saying. Before I knew it, she was at her desk leaving me by myself.

I had never had a job before. I had never worked on a computer, and I didn't know the city because I only went in my own small area. The job consisted of knowing zones outside of where I lived. When she left me, I said, "Okay, God, you gave me this job—now show me what to do. Bring back to my memory what I heard." Every time I would call her for help, she would ignore me, or she would hurry up and answer the phone. My job was to take reservations from clients to get transportation back and forth to the hospital and different doctors' offices.

The Hoy Ghost bought back to mind what I'd observed,

and before I knew it, I was being sent to other departments to work. Not long after that I was training others that were hired after me; I made sure I taught them what I knew. After being treated like that, I didn't want anyone else to experience it.

God was awesome: he not only blessed me with a job, but he blessed me with a home. I still lived in the projects then, always praying and asking God to get me out and to bless me with a house. I might have been raised poor, but I knew how to carry myself, and I knew not to get caught up with the wrong kind of people. Thanks to my dad and his strictness, I promised myself that just the way I entered in there, that was the way I was leaving there. Again I thanked God for saving me at a young age, and for sparing me from the things that Satan really had set up for me and my children. I received a call one day from the pastor, and he said, "Sis, aren't you looking for a house?" I said yes. He said, "Come to the church after work—I have something to tell you." I just knew God had answered my prayers from all that time I was crying out to him. I knew if I waited on the Lord, he would come through for me. He may not come when you want him, but he's always on time. My boys were getting older, and I was worried they would get caught up with the wrong types. There was not peace there, especially at night; all I heard were basketballs hitting the ground late at night. That disturbed our sleep, and it was getting pretty bad living there. We heard gunshots and saw drugs passed around in front of the children. That was the last thing I needed. It was bad enough that my husband got caught up with it again. I felt trapped and couldn't find a way out. This was before I was working; I had no money to save to move.

Back then the devil held over my head how I was going to afford to pay electric, gas, water, and most of all afford a mortgage. I felt trapped. It seemed so impossible, but to God

all things were possible for those that believed. It was Jesus that put that desire in me to go back to school. I had such low self-esteem at that time; I knew I had to get out not just for myself but also for my children's sake. My husband was into some deep things. He had no idea about the spirits he was bringing home with him when he got high.

I learned about different kinds of spirits. I remember when he would come home late at night, I would have bad dreams about demons raping me, and I could hear the devil talking to me, saying, "I could make good use of you." I once had a dream that some men busted into my house and tied up me and my children. They put guns to our heads, threatening to take our lives because my husband owed them money. But I heard the voice of the Lord speak: "You can't have them; they are mine." My marriage became so unbearable. The Lord began to deal with me about my marriage; he let me know my husband was in my life just for a season.

My pastor did not know the seriousness of my torment. He never got into the saints marriage and would always tell us let God work it out. He never interfered in our marriages; he would pray, and if God gave him a message to give us, that's what he did. He let God be God in the situation.

I began to seek God diligently, to get out of the torment of my marriage. God gave me a vision, and in the vision I heard a strong knock at the door. My husband and I thought it was the cops, but it sounded more severe than that, so we hid under the table. All we saw was uniformed men with rifles looking for us. I looked at my husband and told him, "I can't die out here with you. I must die in church."

My husband got worse: he began staying out all night, and when I asked where he was, he would say he was at different neighbors' homes playing cards. I became very suspicious. Whenever I would accuse him of another woman, he would say I was crazy. I asked the Lord to give me proof, because I

knew what I was feeling, and I knew it was not normal for a married man to stay out all night. He would wake me up out a deep, peaceful sleep, calling me sometimes for hours to come downstairs and fix him something to eat. Of course I had to get up early to prepare the children for school and send them off. I know some saints say you must obey your husband, but they left out the part that says, "Obey your husband in the Lord." My husband was not saved or in the Lord at the time, so that would have been foolish for me to obey him while he was listening to Satan. I would sit up half asleep, telling him, "One day you are going to come home, and everything and everyone is going to be gone." He did not believe me because I'd said that for so many years and had never followed through with it.

One night I fell into a deep sleep, dreaming about the place where my husband was. I saw it so plainly, as if I was there. God was so merciful that he did not reveal this to me until I was strong enough to accept it or even face the truth. He was preparing and giving strength all that time. I was bound to my husband. He knew that I was truly saved and watched the transaction take place in my life. He knew that my life had changed. The things I would do, I did, no more. He knew the things that he got away with, he would have never gotten away with before I got saved. It was something, how unsaved folks expect you to walk holy. They use salvation against you and take advantage of you. Or should I say, they *think* they are taking advantage of you. Oh, but we all reap whatever we sow.

God says vengeance is his. I humbled myself and let God fight my battle; he never lost. As I prayed and put it in God's hands, he answered—boy, did he answer. He gave me a clear vision this one night. I saw my husband coming out of a house not too far from where we lived. I woke up, put on my clothes, and went exactly where he was. He was coming

out of someone's house with another woman, just like I saw in my vision. I was hiding in back of our car; I dropped my pride. I would have never humiliated myself any other time, but I had to know. Satan could not lie to me anymore. The woman started to get in on the passenger's side, but she saw me in the back and walked quickly away. My husband didn't see me until I got out and sat up front. He was afraid and couldn't understand how I knew to come there. There was my proof—I wasn't so crazy after all. From that day on, I was free in my mind.

The Bible tells us that the truth will make you free. The Bible does not lie because it was inspired by the Holy Ghost. God chose men to write these truths and testimonies, just like he's using me to write the truth of my life. The disciples truly walked with Jesus as witnesses of the true and living God. God is the same yesterday, today, and forever.

The time came to separate from my husband. It was horrible because I was used to being with him for twenty six years. Still, he that builds a house without God labors in vain. I believed that God would teach me how to be a mother and a father to my children. God became the head of my life and my house. It was not easy raising children without a father in the house. Thanks be to God that I was not alone; he taught me how to deal with each child individually.

We were not good parents—it took God to teach me how to raise my children. I learned how to deal with each one according to his or her personality. I raised them in the Lord, so it was not as hard as it would have been without Christ in my life. They all turned out wonderfully, and I thank God I raised them to know Christ for themselves. They are all grown now and have their own families. All are saved now; they can teach their children about our precious savior. The Scripture tells us to train a child up in the way he should go, and when he gets older, he will not depart from it. As I

said earlier, we would sing, pray, read Scripture, and share testimonies with one another. I'm sorry my husband did not get to share the wonderful gift that God gave us. We have a free will, and he chose to give that benefit up.

God does not intrude on our free will. Oh, there are such wonderful benefits in serving Christ. He will protect you, and Satan cannot do to you what he desires to do. He has to get permission from God before he could touch our lives; once we are saved, and if God gives him permission to buffet us, it is for the building up of our character—to bring us out of darkness and to bring about a change in us. All things work together for the good to those that love the Lord and are a called according to his purpose. We do not realize that God created good as well as evil. "All things are made by him." God uses evil to bring about good. If we were always feeling good and our lives going well all the time, then we would have no need of him in our lives; we would not call on him for help. Even the best of us that say, "We did no wrong," need God—the rich as well as the poor, the strong as well as the weak. God is the one that allows us to get rich, but if we do not have Christ in our lives, we are like a ship without a sail, tossed to and fro. We cannot make it down here without our creator. If sickness comes, money can't buy healing; if your heart is broken, money can't mend your broken heart. Yes, we need money to survive, but some things money can't buy. God is all, in all, and above all. He is able to do exceedingly above all we can ask or think. He is the God of the rich and the poor. If you let him in your heart, he can become all that you need in your life. If your mind is troubled, he can bring peace to a troubled mind. if you're misunderstood, he can take away confusion because God is not the author of confusion but of love, peace, and a sound mind. He is the great I Am. I pray that you will learn to put your trust and faith in him as he taught me to do.

Get to know him for yourself, and you can have him as your personal savior. You can confide in God and not have to worry about whether he told anyone. There are things that all of us have experienced and cannot tell anyone, yet we wish there was someone we could tell and not be ashamed. You can tell Jesus, and he will listen, not condemned you. Not only will he listen, but he can do something about it. He will help us in the most secretive places in our lives. Why tell a friend or a loved one when they might not understand and can do nothing about it anyway? Jesus can go way back into our childhood from the time we were born and undo things that we had no control of anyway. We were born in sin and shaped in iniquity.

I thank God for who he is in my life. I now have a Christian family that loves me with agape love. The Lord made something beautiful out of my life. He took a nobody, "can't do anything," "never amount to nothing," and he made me a child of the king. He is using me in a way that I never would believe. He has showed me things that the angels dare not look into. Praise God, for he is the king of kings and the Lord of Lords.

After I was saved, I experienced the love of God, and I wanted to share the good news all over the world. I prayed and asked God if he would allow me to do something, maybe leave behind something good and positive here before I left this world. I wanted to do something that would affect somebody's life, somebody who was not raised to have knowledge of God. He said, "Write a book. Tell about your life experience." I did not write this book just to tell a story or to let the world know about my private life. I wrote this praying that someone who had a difficult life and childhood, as I did, would get a hold of it.

I want readers to truly know that God is truly a deliverer. You see, I did not have a "death after life" experience like I

read about in other books, but I sure had a "life after death" experience. The Bible says if you lose your life, you shall find it. I pray in the name of Jesus that God will bless whoever picks up this book and reads it. I pray that you will get all that you can, and all that God intends for you to get out of this book.

I pray that you feel the anointing and that the power of God will arrest you and bring you to repentance. I would like to say a prayer with you also.

Dear heavenly father, we bow our heads as a sign of humility before you in the name of your son, Jesus the Christ, asking that you would bless the readers of this book. Allow them to comprehend what was written, and please lead them into repentance. I ask you to pardon their sins and forgive them of all that they did knowingly and unknowingly. In the name of Jesus, come into their hearts and live in them. Do a good work in them, as you have done a good work in me.

> Teach them how to seek you with all their heats, souls, and minds, so that they will get to know you for themselves, knowing that you will stick closer than any human can ever stick to anyone.

I thank you in Jesus's name. Amen.